HAPPY MASSEE

DIARY of A SET DESIGNER

polaroids

Like the Cinematographer's light meter, the Polaroid was once the Set Designer's tool. The crude mechanical shutter of the Polaroid camera was followed by the ejection of the image squeezed through the stainless steel rollers with its characteristic pewking and growling sound. Then when fully developed, Happy would hold the image and luxuriate. Why not, he was photographing through the medium of Dr Edwin Land's process where everything was conferred with a chemical magic. But in his peripatetic images, we glimpse a crude and noble world that is impressionistic, abstract and effortless. To see Happy's Polaroids is to see through the spectrum of a master stylist. Everything is on par, a prancing Rolling Stone is no more or less than a stained Mexican pissoir. Although the Polaroid is the revelation of the instant amateur, it's a dangerous tool in the wrong hands. Happy's eye roves on the periphery of his sets that are peopled by the gargantuan egos of that era; directors, photographers and celebrities. Here he builds these temporal worlds (sets) for them and then he quietly retreats turning his camera onto textures, friends and lovers. There's something of the American boy raised on the streets of Paris within these images. The urchin once armed with a blade now cuts deeper with these blurred pyscho-chemical invitations to dream of a space between waking and sleeping. The fragments of his life imprinted on these pages outlive the sets long torn down. —Malcolm Venville

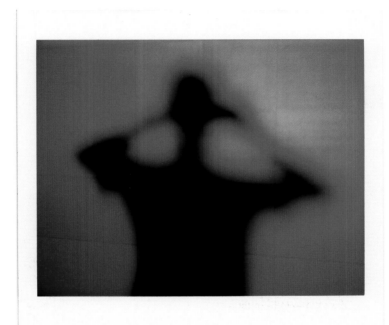

I was driving down La Brea one day with my friend Denise. I noticed Fabio driving in the the car next to me. We caught up with him at the traffic light so I asked Denise to discretely pass me my Polaroid. She grabbed it from the back seat and handed it over, but just as I aimed it in his direction, he caught sight of me. I lowered my camera quickly but then I noticed him crack a smile and as he did so, he opened the sunroof to his Mercedes and encouraged me to take his portrait. Now he was bathed in a shaft of warm LA sunlight. I miss my Polaroid, my constant companion. Way before we had computers, it was the first thing I would pack before going on a trip. It was more than just a camera. It was a commodity. All in an instant, in a blink of an eye, my travels would immediately be recorded. As a kid, I was always amazed by my father's Polaroid Pathfinder 110A. In its elegant brown leather case, he would pull it out, snap it open and take pictures that for some reason were forever streaked, darkish brown or overexposed. He was a terrible photographer but he would always apply the fixative stick and proudly save them as great masterpieces. I used a Spectra model with all its settings but I would never mess with them. I used no filter, made no adjustments, I didn't even know what an f-stop was. There was no Photoshop or dark room trickery. It was all about what came through straight onto the emulsion. We'd rub the pictures against our sweaters making them develop faster and the outcome was always a surprise. It was like a good wine, sometimes we got a good vintage sometimes we didn't. When I first started traveling as a set designer, I'd use the pictures as

reference, presenting props, locations and set builds to my director. It was my tool. When it broke I'd run to the store to buy another, in the same way I would a measuring tape. There was no time to use a point and shoot film camera, decisions had to be made there and then. I would go through dozens of "10 packs", collecting hundreds of images that would end up on my hotel room floor, waiting to be thrown out by the housekeeper. One day my assistant was going through a stack of pictures and he pointed out how good and unusual some of them were. We put a few aside. I guess that's when I first started saving my Polaroids, filling shoe box after shoe box never sure of what I would do with them. Most of my pictures were never intentional, they didn't feel cerebral or have that SX70 quality that David Hockney elevated to an art form. They were merely accidental. Sometimes they were a way of putting a smile on a child's face or thanking someone for their help. They were just about the things I saw, people I met and the places I had travelled. I stopped taking Polaroid pictures about 20 years ago, at the beginning of the computer age. The instant camera was made obsolete by the speedier and more practical digital camera and smart phone. It was later announced that the Polaroid Corporation was going to close its doors, and film would no longer be available. I made a photo album with some of my pictures, which sat on my coffee table for a long time. Every time someone came over, the reaction was the same. They weren't reacting to the pictures themselves, but more to the story they told. That's when I decided to share those stories, using some of the images that I had saved for so many years...

polaroids

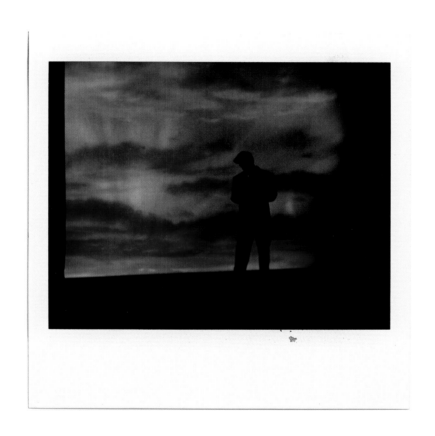

CHRIS ISAAK, LOS ANGELES, 1992

TUCSON, 1996

Rome, 1996

ESSAOUIRA, MOROCCO, 1998

LAKE PLACID, NY, 1997

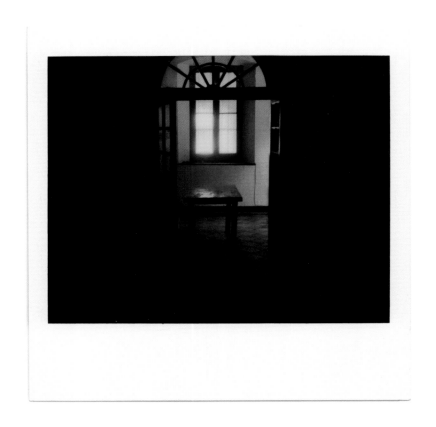

Barcelona, 2000

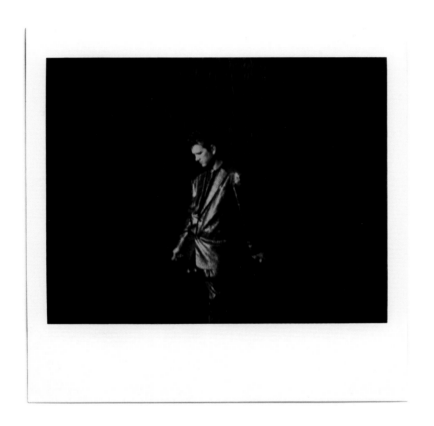

CHRIS ISAAK, LOS ANGELES, 1992

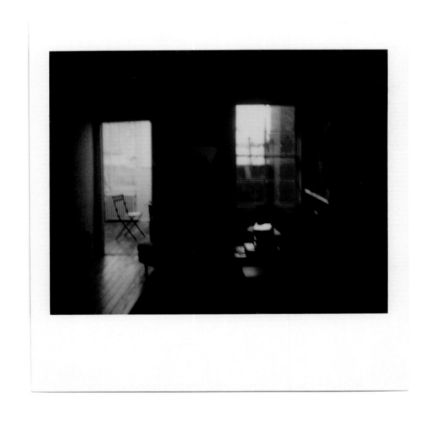

605 HUDSON ST, NYC, 2000

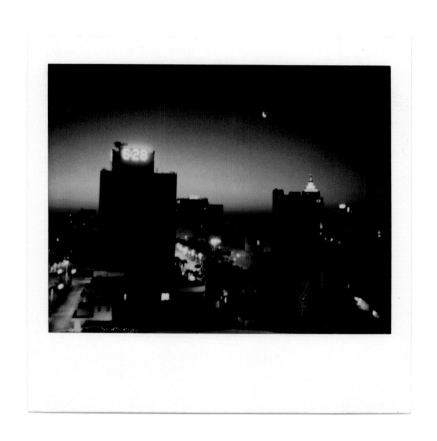

MIAMI 6:28 AM, 1999

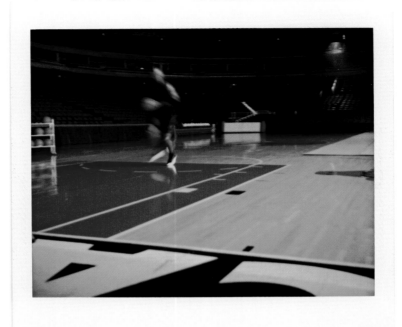

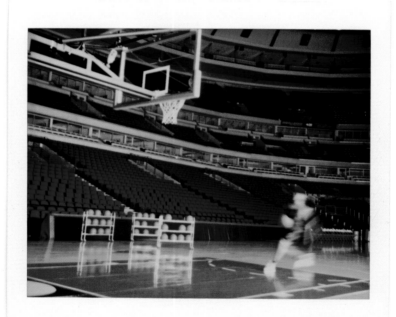

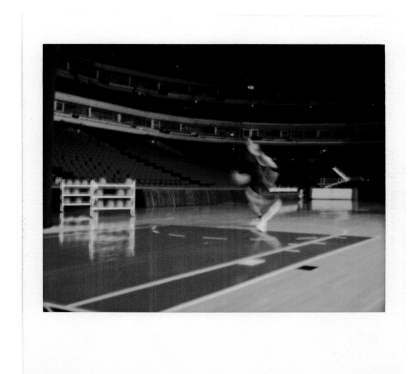

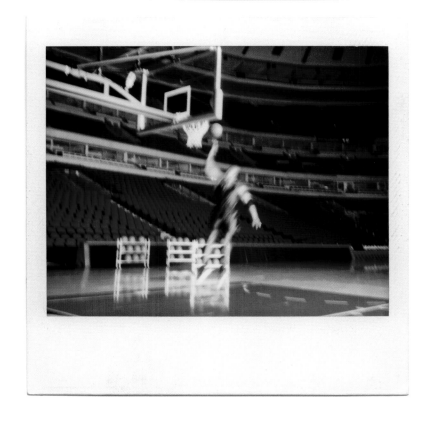

MICHAEL JORDAN, CHICAGO, 1997

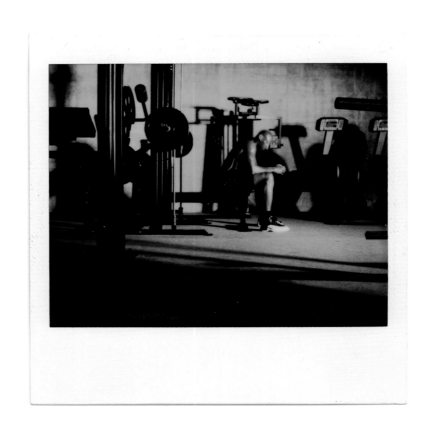

MICHAEL JORDAN, CHICAGO, 1997

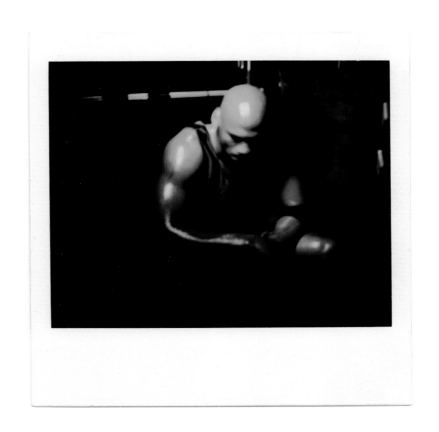

MICHAEL JORDAN, CHICAGO, 1997

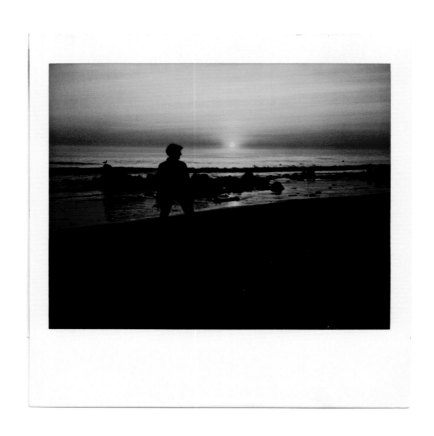

GINA, MALIBU, 1994

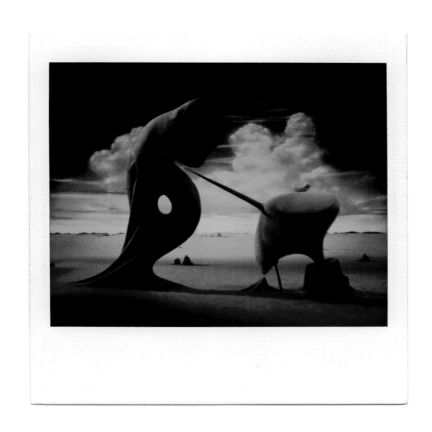

SHEPPERTON STUDIOS, 1994

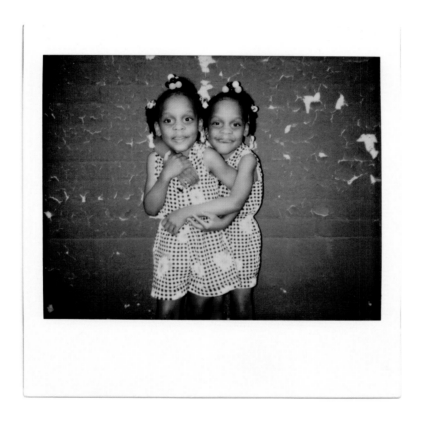

TWINS, CHICAGO, 1999

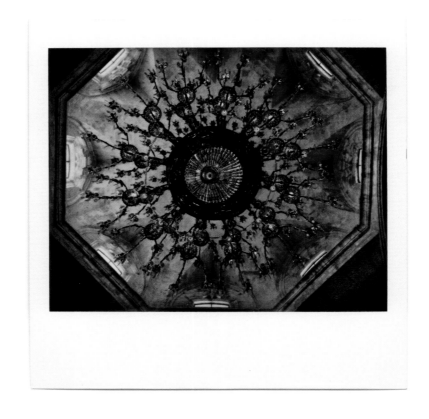

HAVANA, 1997

PLAZA HOTEL, HAVANA, 1997

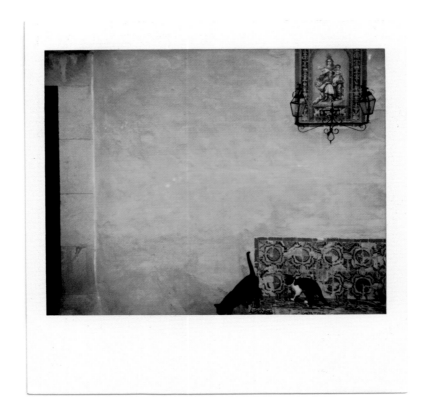

RONDA, 1994

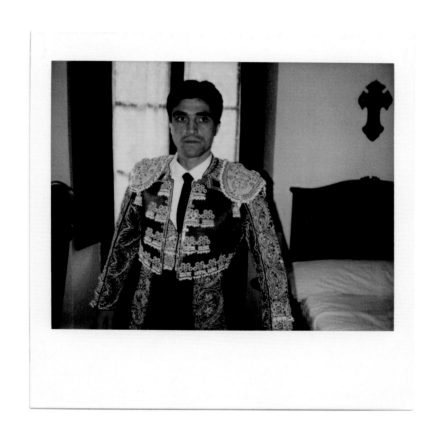

EMILIO MUÑOZ, RONDA, 1994

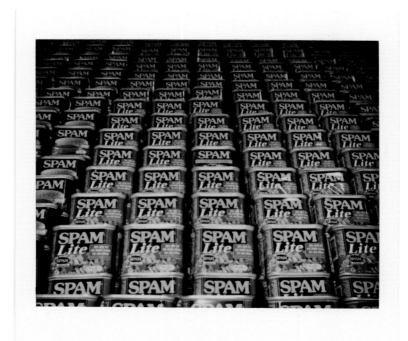

SPAM, LAKE PLACID, 1997

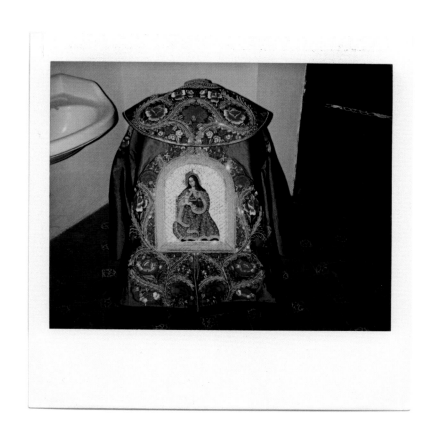

RONDA, 1994

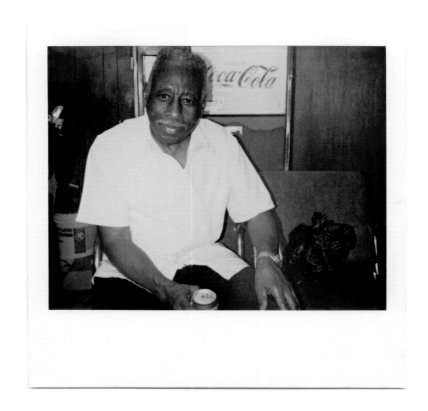

BROOKLYN, 2006

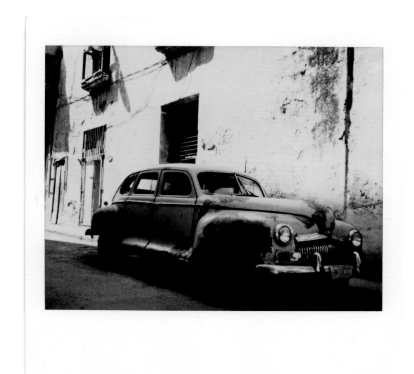

HAVANA, 1998

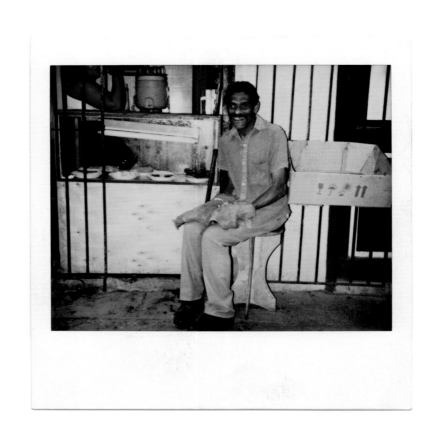

HAVANA, 1997

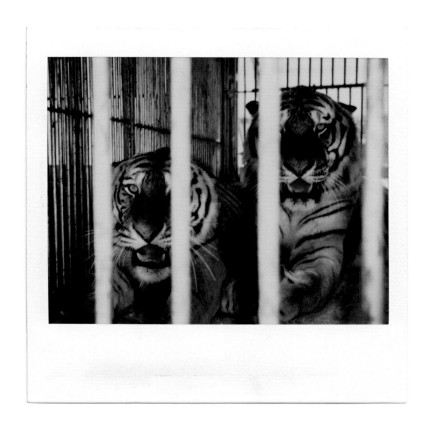

TIGERS, MILAN, 1994

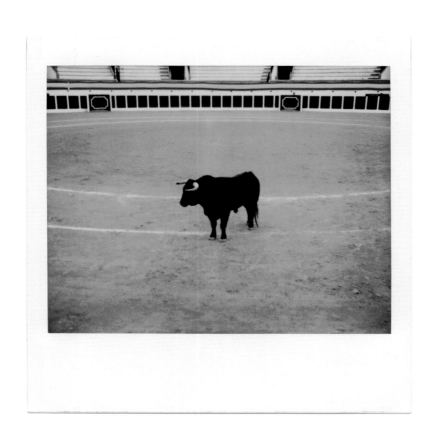

BULL, ANTEQUERA, SPAIN, 1994

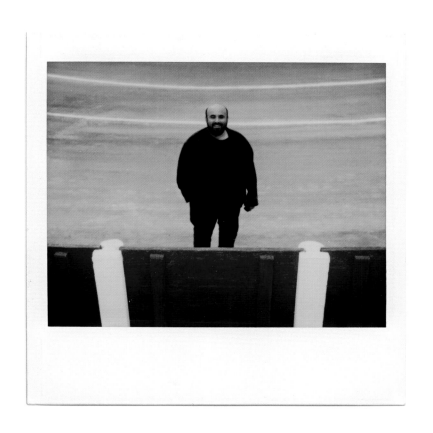

HARRIS, ANTEQUERA, SPAIN, 1994

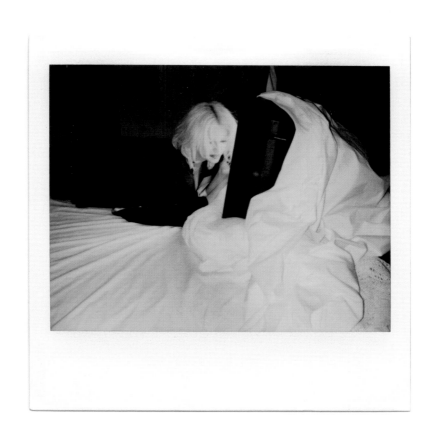

MADONNA, RONDA, SPAIN, 1994

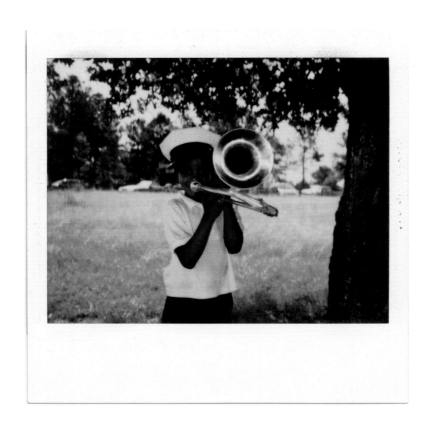

NEW ORLEANS, 1992

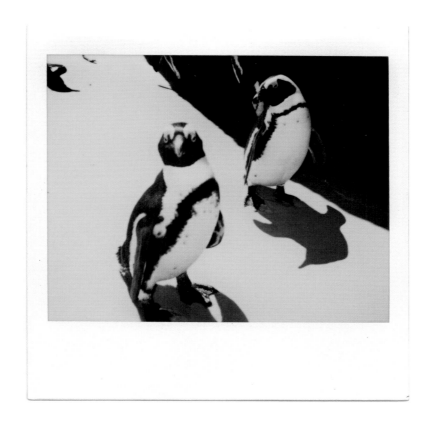

PENGUINS, CAPE TOWN, S.A., 2001

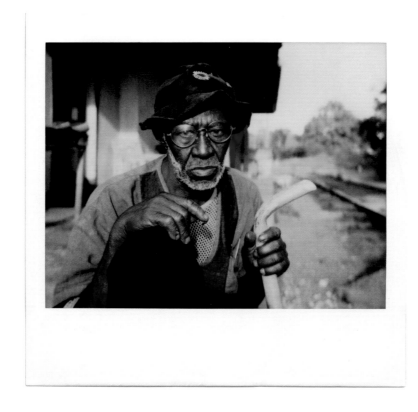

PORT ANTONIO, JAMAICA, 1995

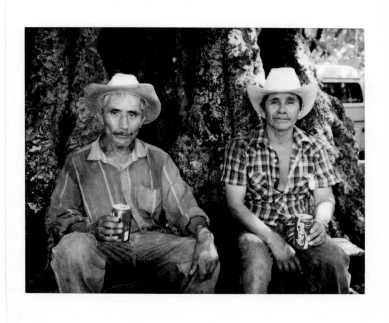

XILITLA, MEXICO, 1995

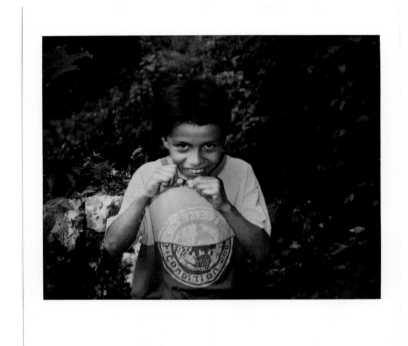

XILITLA, MEXICO, 1995

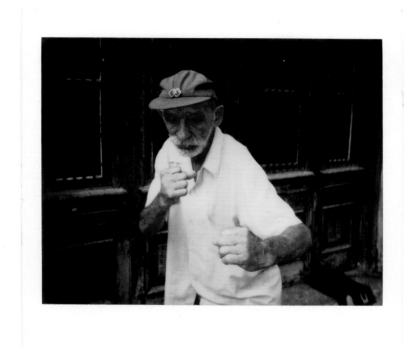

HAVANA, 1997

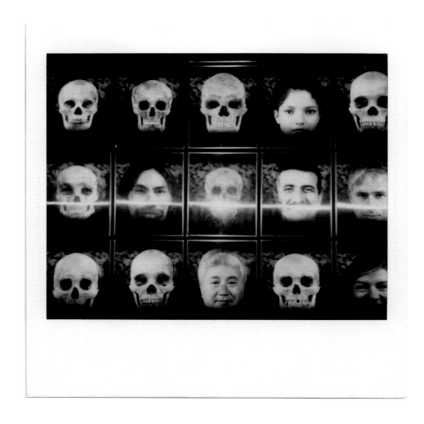

MUSEO DE ANTROPOLOGÍA, MEXICO CITY, 1994

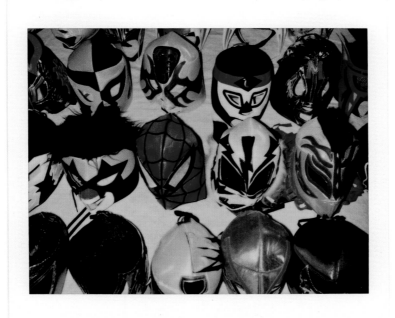

MEXICO CITY, 1994

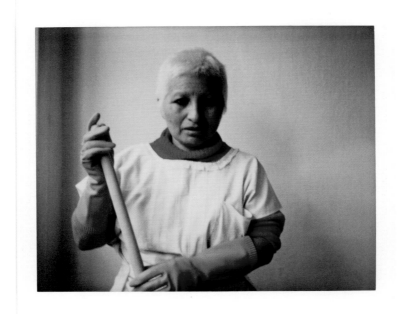

JANITOR, BUENOS AIRES, 2004

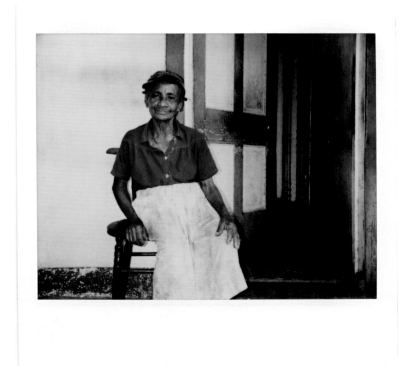

PORT ANTONIO, JAMAICA, 1995

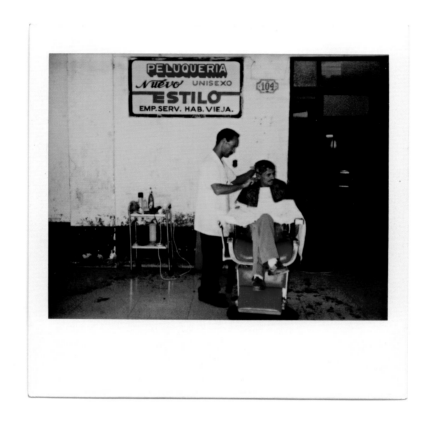

HAVANA, 1997

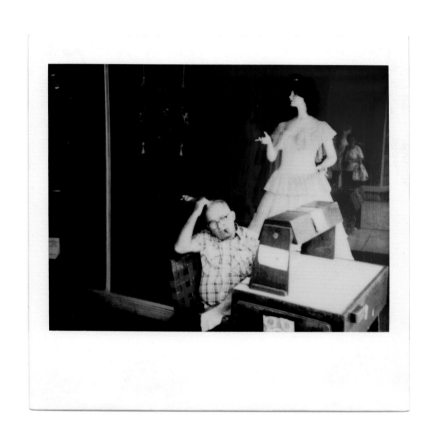

HAVANA, 1997

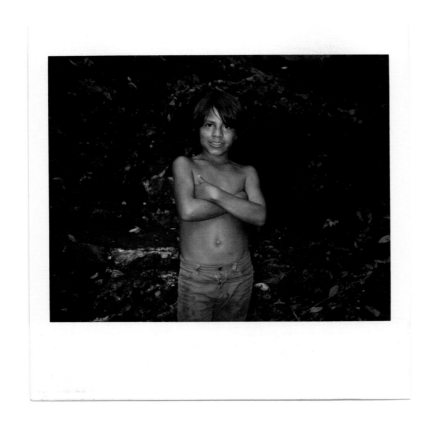

XILITLA, MEXICO, 1995

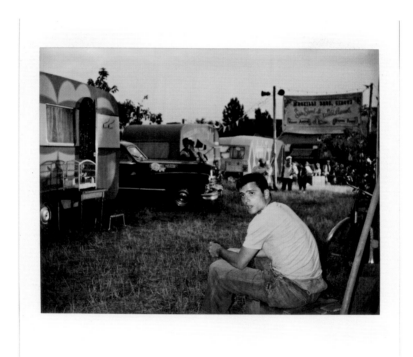

JOHN, MILAN, 1994

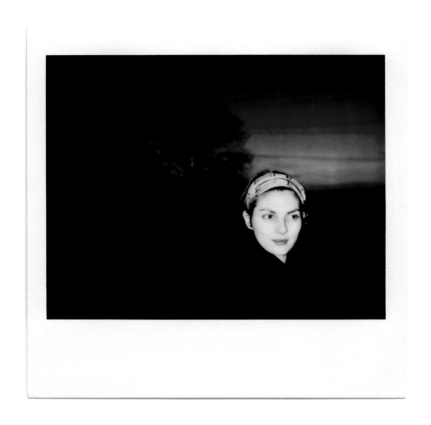

GINA, WALES, 1995

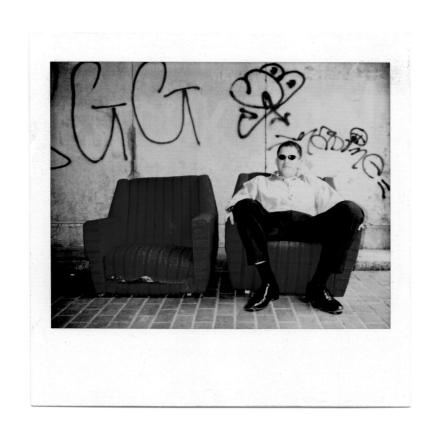

MO, BUDAPEST, 1997

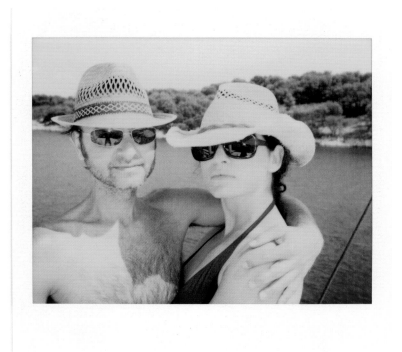

FISHER & JULIANNA, CROATIA, 1994

MIAMI, 1999

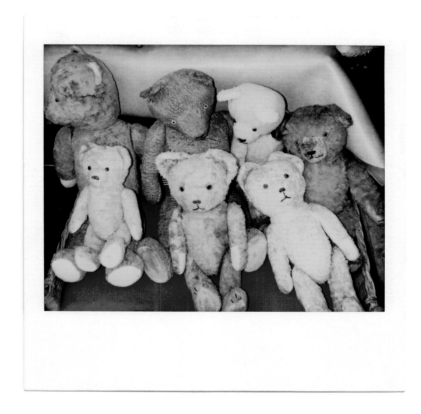

FLEA MARKET, BUDAPEST, 1997

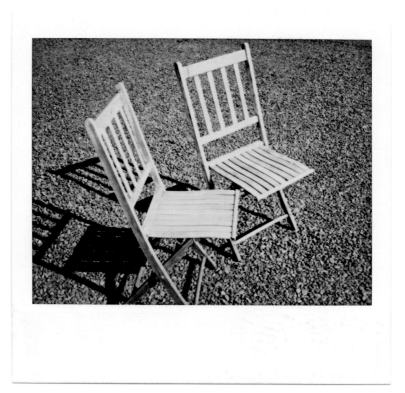

CHAIRS, PORTLAND, 1995

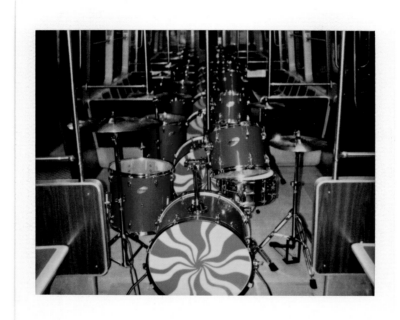

NEW YORK CITY, 2003

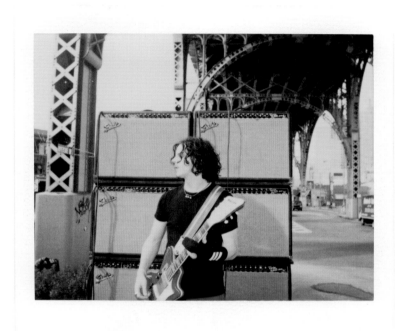

JACK WHITE, NEW YORK CITY, 2003

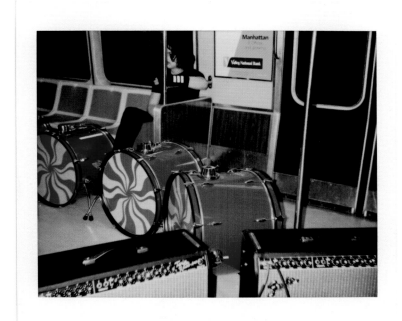

JACK WHITE, NEW YORK CITY, 2003

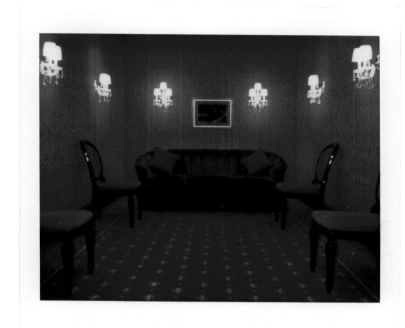

RED ROOM, SAN FRANCISCO, 1997

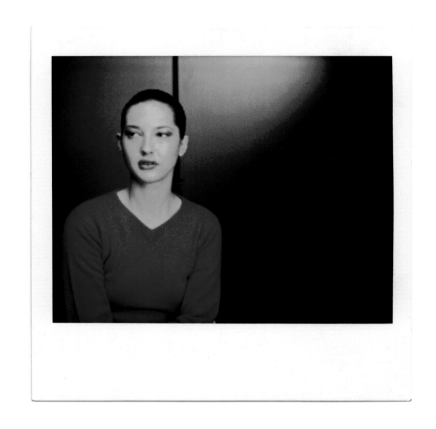

ALEXIA, NEW YORK CITY, 1997

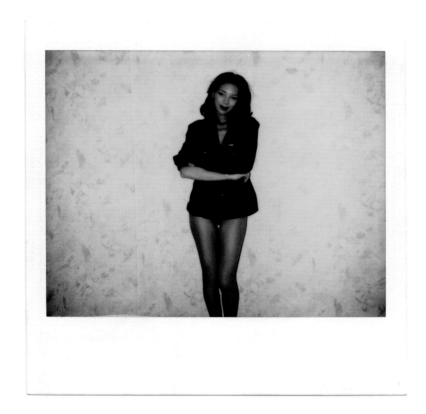

GIRL, BUDAPEST, 1997

MATT, NIAGARA FALLS, 1997

FLEA MARKET, MEXICO CITY, 1995

CORY, MONTEREY, 1991

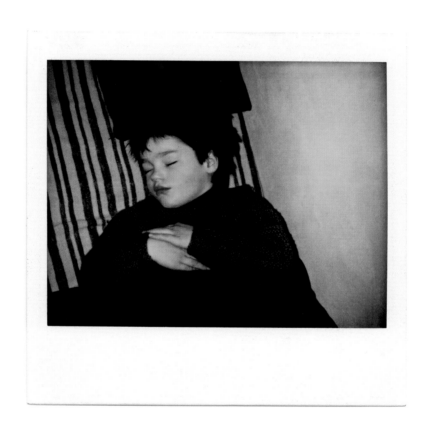

DIEGO, SANTA FE, 1997

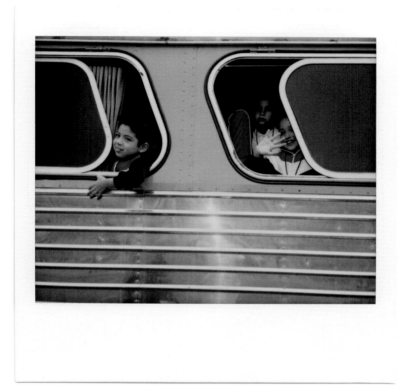

MEXICO CITY, 1994

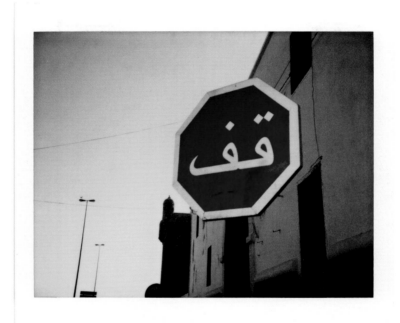

ESSAOUIRA, MOROCCO, 1998

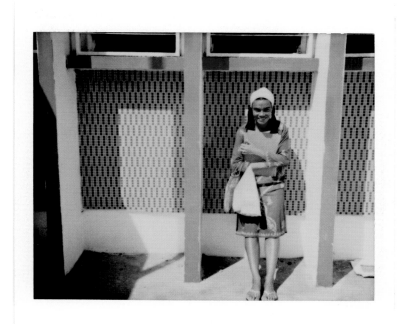

MARIE-ANNE, MADAGASCAR, 1997

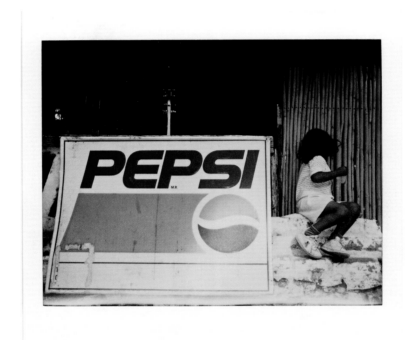

XILITLA, MEXICO, 1995

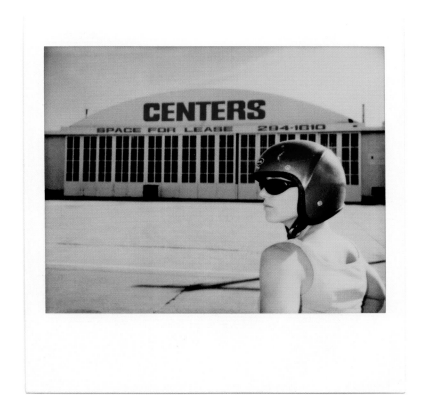

SIOUX, TUCSON, 1996

MARRAKESH, 1998

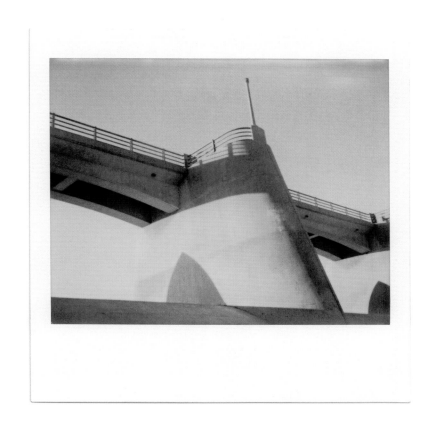

SEPULVEDA DAM, LOS ANGELES, 1997

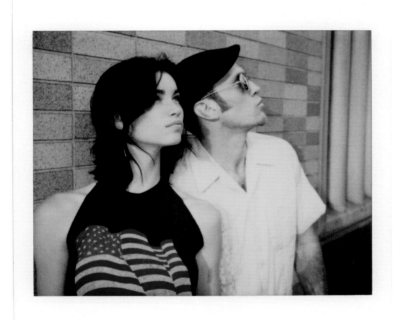

ANNIE AND SEAN, NEW YORK CITY, 2004

TORONTO, 2000

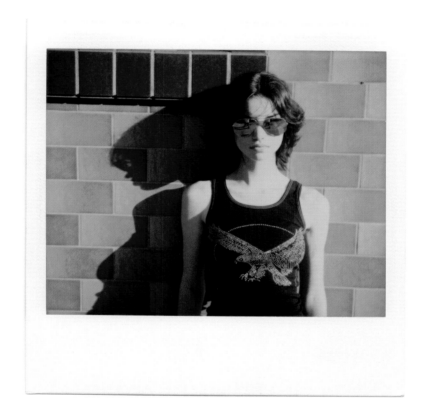

ANNIE, TORONTO, 2000

SPAM 2, LAKE PLACID, 1997

BONDI BEACH, 2001

NEW ORLEANS, 2001

RIO DE JANEIRO, 2002

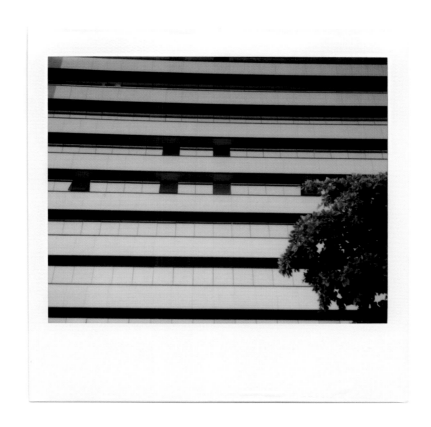

SIDNEY, 2001

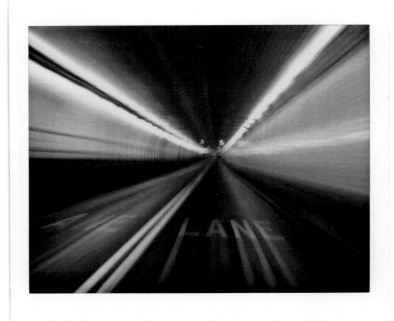

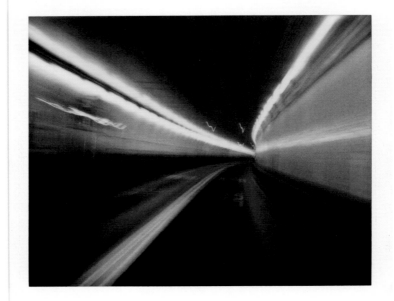

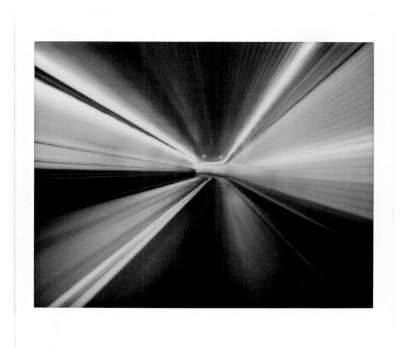

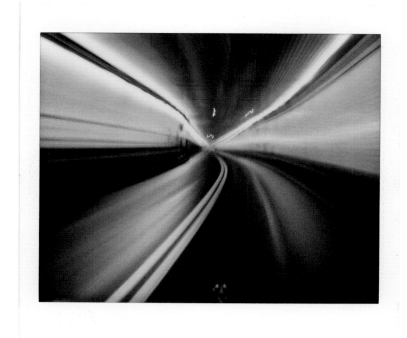

HOLLAND TUNNEL, NYC, 1995

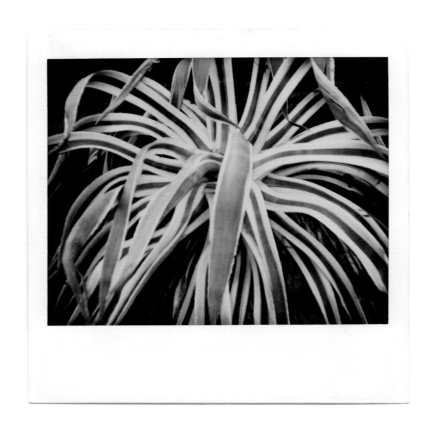

LAUREL CANYON, LOS ANGELES, 1997

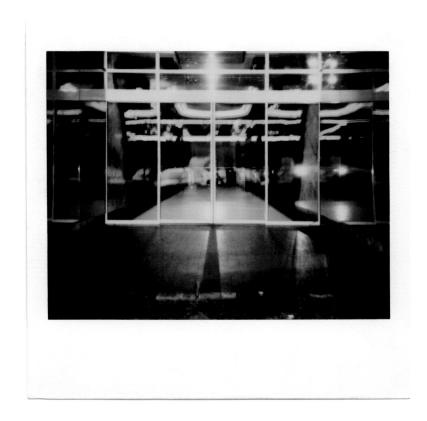

BUDAPEST, 1987

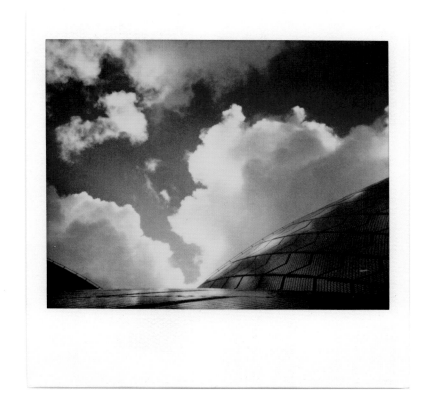

SIDNEY, 2001

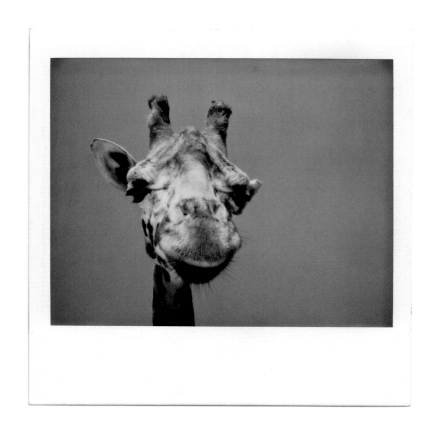

MILAN, 2001

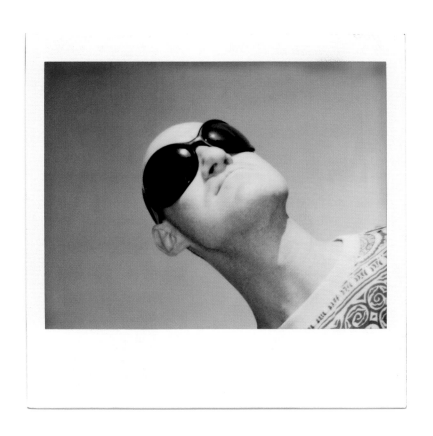

DAVID, PIRU, CA, 1992

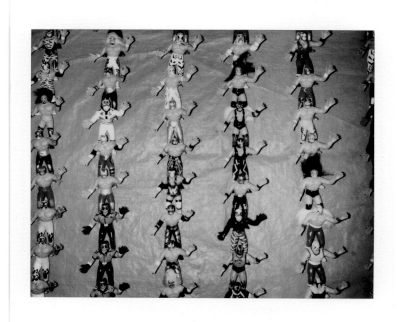

MEXICO CITY, 2004

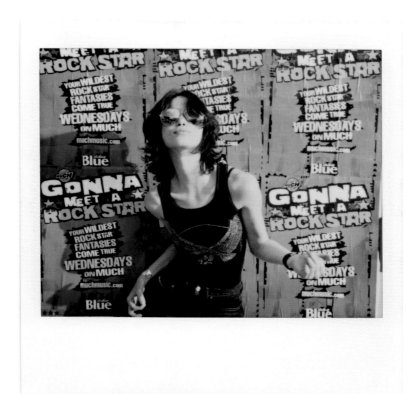

ANNIE, TORONTO, 2000

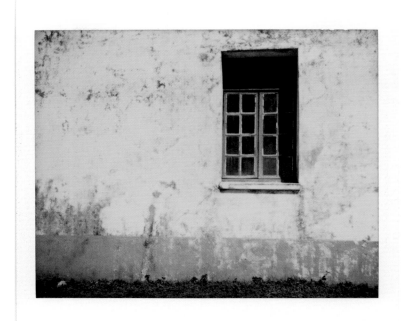

MADAGASCAR, 1997

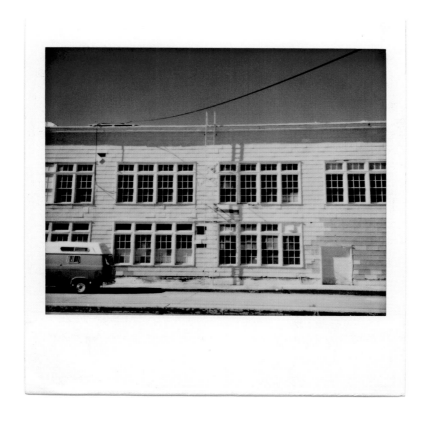

Tucson, 1996

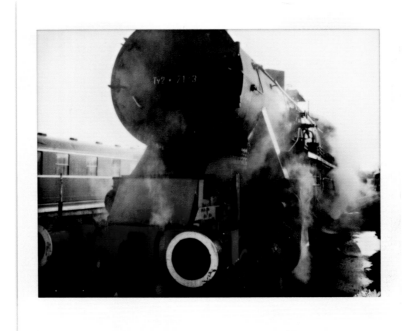

STIBBINGTON, UK, 1992

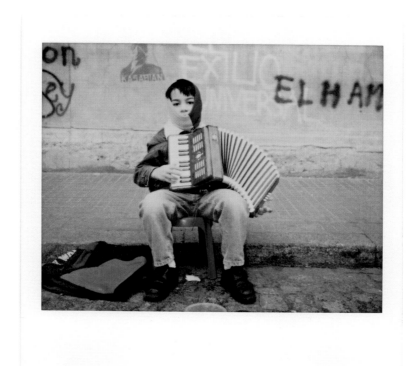

ACCORDIAN BOY, MEXICO CITY, 1994

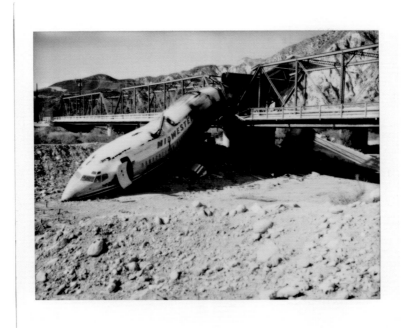

MALIBU CREEK, 1992

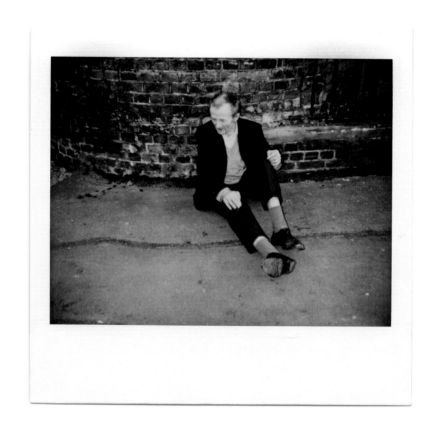

WINO, LONDON, 1995

MALIBU CREEK, 1992

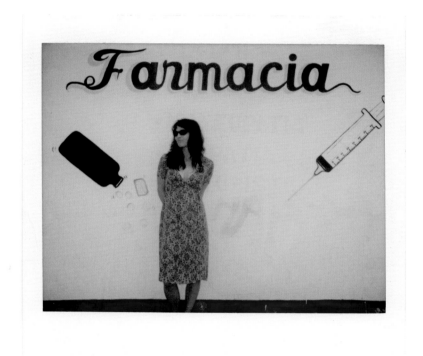

ROSETTA, TODOS SANTOS, MEXICO, 1998

NEW YORK CITY, 1996

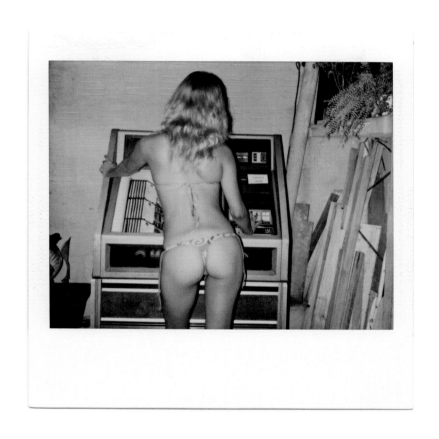

VILLA MIMOSA, RIO DE JANEIRO, 2003

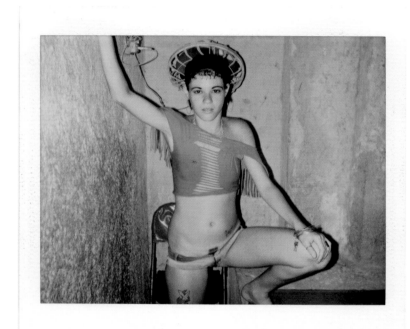

VILLA MIMOSA, RIO DE JANEIRO, 2003

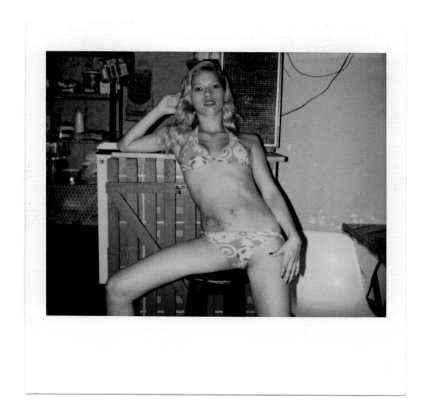

VILLA MIMOSA, RIO DE JANEIRO, 2003

VILLA MIMOSA, RIO DE JANEIRO, 2003

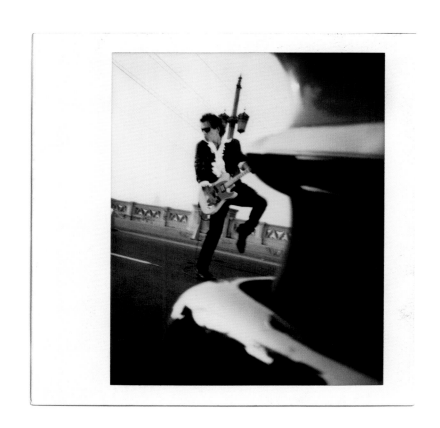

KEITH RICHARDS, LOS ANGELES, 1992

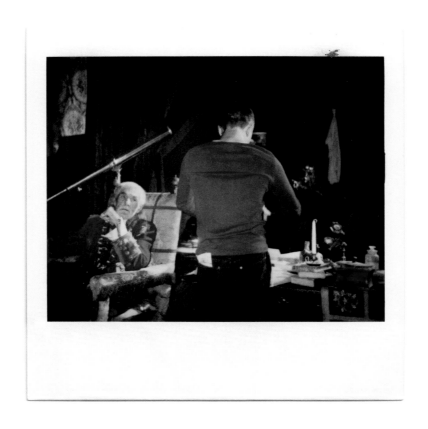

TIMOTHY LEARY & JAKE SCOTT, LOS ANGELES, 1995

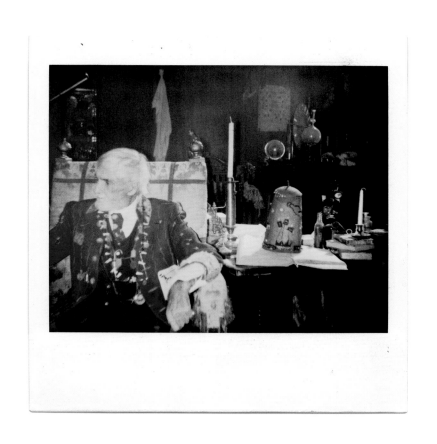

TIMOTHY LEARY, LOS ANGELES, 1995

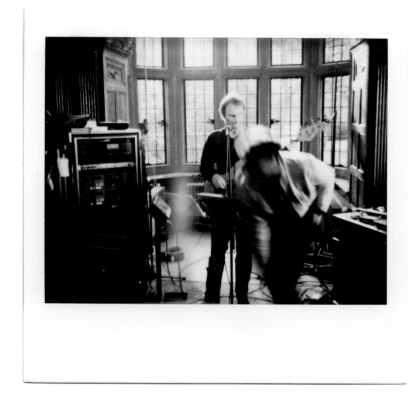

STING, WILTSHIRE, UK, 1992

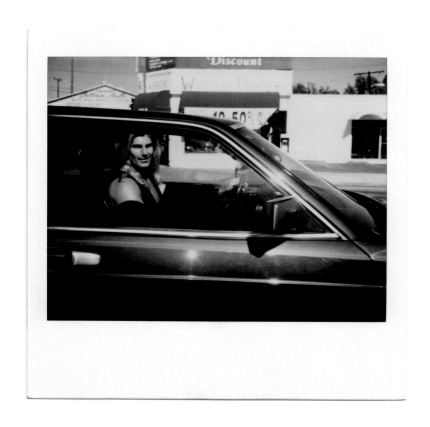

FABIO, LOS ANGELES, 1999

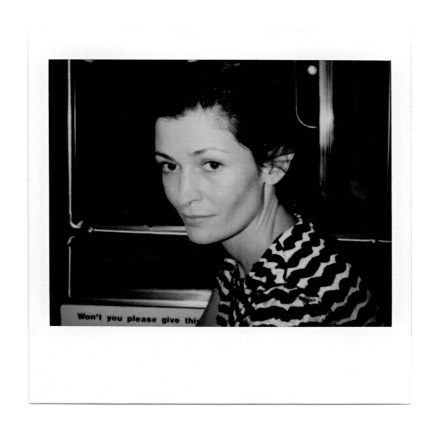

JANE, NEW YORK CITY, 2002

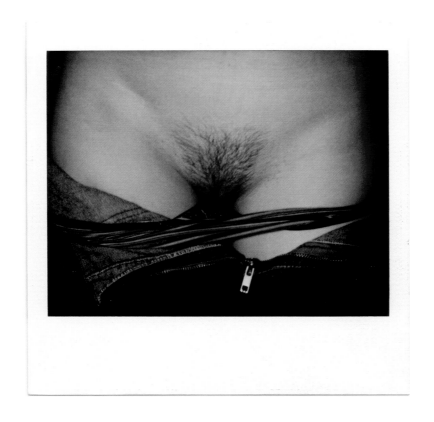

ONDINE, PARIS, 1993

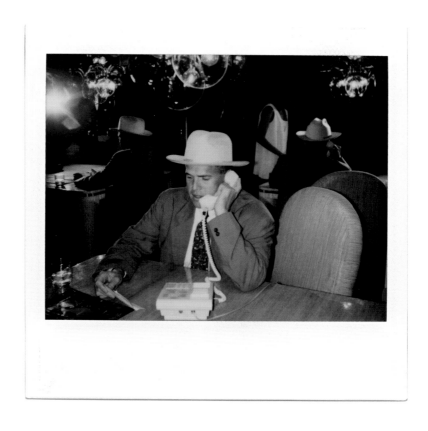

MO, LAS VEGAS, 1992

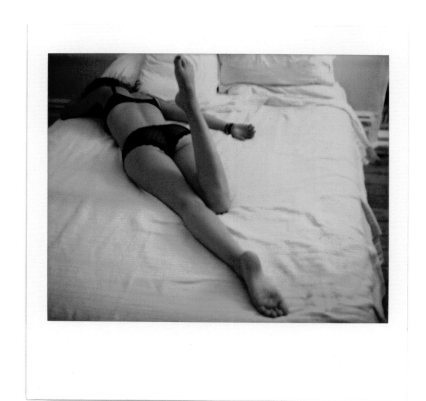

JERUSHKA, NYC, 1995

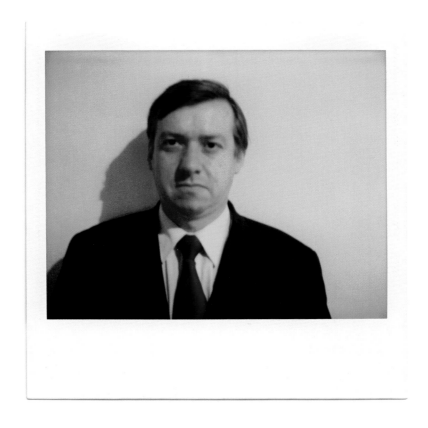

BUENOS AIRES, 2004

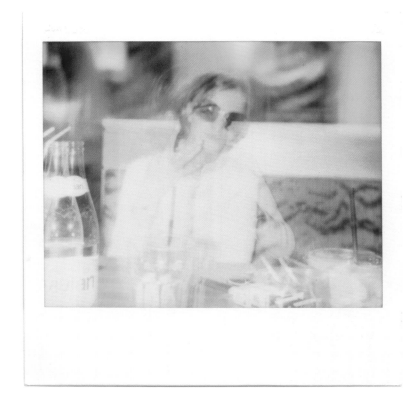

SAMANTHA, LAS VEGAS, 2001

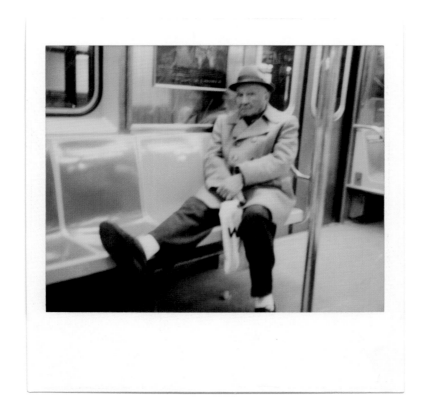

SUBWAY, NYC, 2000

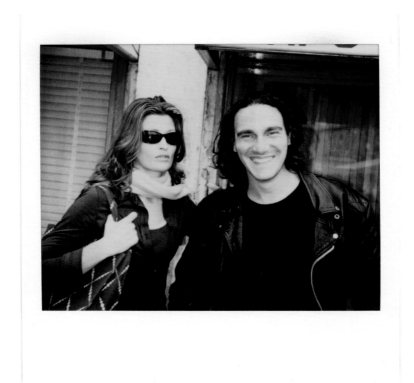

JANE AND PAOLO, ROME, 1996

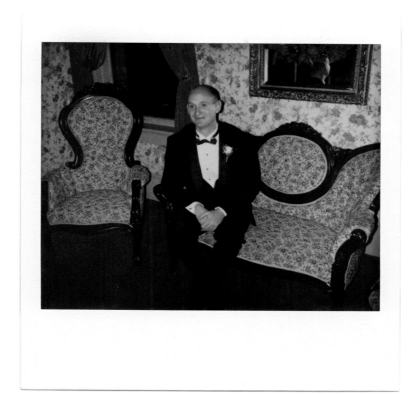

DAVID, DENVER, 1994

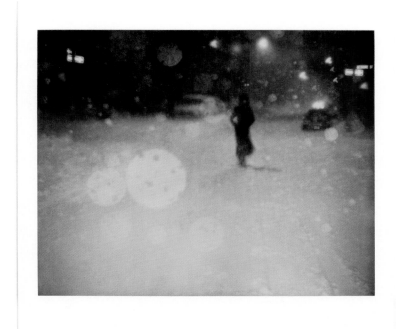

JANE, NYC BLIZZARD, 1996

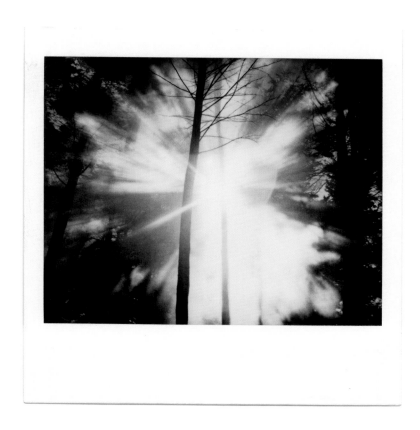

SAN FRANCISCO, PRESIDIO, 1997

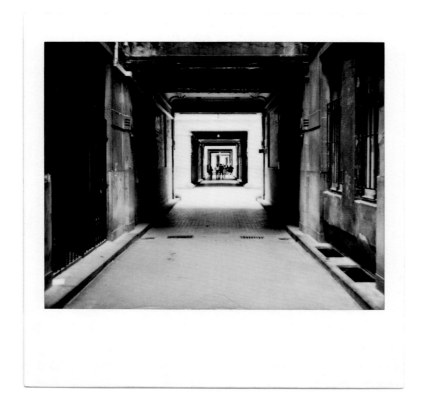

BUDAPEST, 1997

ESSADUIRA, MOROCCO, 1998

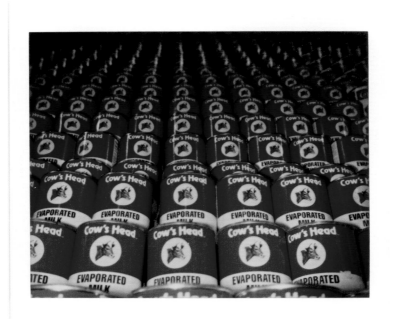

COW'S HEAD, LAKE PLACID, 1997

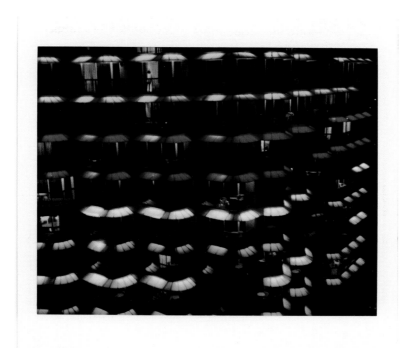

BAHAMAS, 1998

SIDNEY, 2001

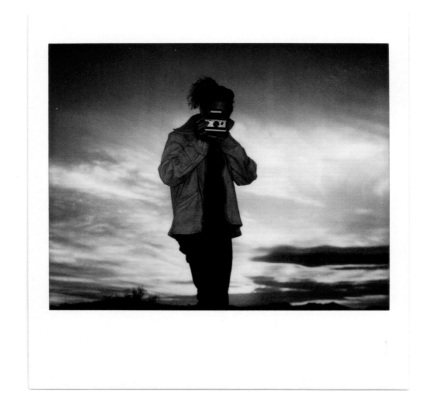

Sioux, Tucson, 1996

THANK YOU

Michael Haussman	Doug Nichol
Malcolm Venville	Timory King
Riccardo Ruini	Marc Benaceraf
David Lucas	Mark Romanek
Mo Ortiz	Russell Steinberg
Matt Badger	Noah Bogen
Daisy Bates	Vincent Warin
Jane Mayle	Jake Scott
Fabien Baron	Didier Canaux
Andrea Damiani	Holly Miller
Robert Molnar	David Hazan
Meg Burnie	Larry Bercow
Zoe Cassavetes	Mike Williams
Brianne Almeida	Jimmy Gilroy
Amber Bembnister	Felicity Miller
Anne-Gael Senic	BJ DeLorenzo
Eve Therond	Christina Martinez
Pete Zumba	Maxime Poiblanc
Heiko Keinath	Alicia Shreders
Aleksandra Woroniecka	Brian Hetherington
Aaron Stern	Mina Viehl
Harris Savides	The entire Massee Family
Denise Milford	Holly and Jack, Robin
Leigh Hurst	Mike and Kim

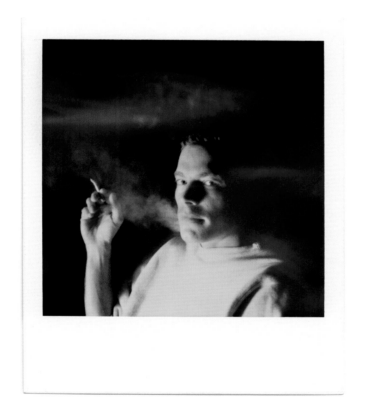

FOR MIKE

Diary of a Set Designer
Happy Massee

Damiani 2016
Photographs, Happy Massee
Foreword, Malcolm Venville
Book Design by Fabien Baron

Published by Damiani
info@damianieditore.com
www.damianieditore.com

Printed in June 2016 by Grafiche Damiani
Faenza Group SpA, Italy.
ISBN 978-88-6208-485-7